ROBERT UPSTONE

Turner: The Second Decade

WATERCOLOURS AND DRAWINGS FROM

THE TURNER BEQUEST 1800–1810

THE TATE GALLERY

cover
Kew Bridge *c.*1805–6
(cat.no.30)

ISBN 1 85437 006 5
Published by order of the Trustees 1989
for the exhibition of 10 January – 27 March 1989
Copyright © 1989 The Tate Gallery All rights reserved
Designed and published by Tate Gallery Publications,
Millbank, London SW1P 4RG
Typeset in Monophoto Baskerville
Printed by Balding + Mansell UK Limited, Wisbech, Cambs
on 150gsm Parilux Cream

Contents

Foreword

This is the second exhibition in our annual series devoted to a survey of Turner's graphic output decade by decade. It shows us the artist in his first maturity, an established master of serious landscape and a respected Royal Academician. In this decade historical subjects, genre scenes and picturesque rusticity alternate among his exhibited works, constantly reminding us of his broad interests, his refusal to be 'labelled', and his ambitions for the public image of landscape painting in the modern world. At the same time his devotion to the Old Masters is never more apparent, not only in the reverent studies he made in the *Studies in the Louvre* sketchbook but also in the repeated allusions to Titian, Ruysdael, Claude and Poussin in his finished works, and even at times in his sketches and studies.

Another important aspect of his output remained the painting of marine subjects, and in this decade no event at sea so stirred Turner's imagination as did the Battle of Trafalgar, fought in 1805. A section of the exhibition is dedicated to his response to it, and to the death of Nelson. The exhibition has been selected and catalogued by my colleague Robert Upstone, and he is grateful for the help which he has received on cataloguing from Richard Spencer.

Nicholas Serota *Director*

Introduction

The period 1800–1810 was one in which Turner consolidated his youthful success, demonstrating his ability in a series of ambitious works and projects. It was also a period during which he gained full professional recognition. On 12 February 1802 Turner was elected to the position of Royal Academician – a remarkable achievement for one so young; he had been an Associate for just over two years. By 1803 he had been elected a Royal Academy Councillor for the statutory two-year period, and by 1807 he had become Professor of Perspective for the Academy schools, although he was not to start lecturing until 1811.

At the annual spring Academy exhibitions Turner was exhibiting a range of works, from landscapes and sea pieces displaying his deep empathy with nature in all its forms, to History paintings such as 'Holy Family' (Gallery 107) influenced by the Old Masters, whom Sir Joshua Reynolds had held up as examples for modern painters to follow; he also exhibited rustic genre subjects like 'A Country Blacksmith disputing upon the Price of Iron' (Gallery 108) influenced by the young Scottish painter David Wilkie (1785–1841). In April 1804 Turner opened his own gallery in Harley Street in which he displayed many of his best paintings and drawings leading one critic to accuse him of only sending inferior work to the Academy.

Turner's watercolours and drawings display an eclecticism of subject and style equal to if not greater than that of his oils, and the display has been organised thematically to stress this. In June and August of 1801 Turner toured Scotland for the first time, having been advised of places to visit by his friend the artist Joseph Farington (1747–1821). The Scottish landscape seems to have inspired Turner towards a more technically expressive and fluent approach to his drawings, and on his return he produced water-colours of great subtlety, telling Farington that he considered Scotland 'a far more picturesque country to study in than Wales'. Notably on this tour Turner produced the 'Scottish Pencils' (cat.no.5), energetic pencil sketches made on large sheets of paper prepared with a brown wash and afterwards heightened with white bodycolour.

As soon as the Peace of Amiens was signed on 27 March 1802 between Britain and France, temporarily suspending the Napoleonic wars, Turner, in common with many of his fellow Academicians, made plans to visit the Continent, and he set off on 15 July. His crossing of the Channel was a stormy one, and the arrival of the English packet in which he had travelled

was depicted in some vivid sketches in his sketchbook (*Calais Pier* sketchbook, cat.no.51) and in the following year in the oil painting 'Calais Pier, with French poissards preparing for sea; an English packet arriving' (National Gallery, London). Turner travelled through France and Savoy to Switzerland where he recorded the dramatic scenery and atmosphere of the Alps and their valleys in a large series of drawings that are frequently as impressive in scale as they are for their dynamic technique (cat.nos.7–15). Turner commented to Farington that 'The lines of the Landscape features in Switzerland [are] somewhat broken, but there are very fine parts'; his Swiss experiences were later to be recalled in a sequence of finished watercolours, as well as in the dramatic setting and stormy effects of his painting 'Snow Storm: Hannibal and his Army crossing the Alps' exhibited in 1812 (Gallery 107). On his return Turner visited Paris and was greatly impressed in the Louvre by the old master paintings Napoleon had gathered there. His subsequent work showed the influence of Poussin, Titian and above all Claude. Some of his studies for history paintings such as 'The Deluge' (cat.no.21), a direct response to Poussin's painting of the subject, are exhibited.

Turner's interest in the epic possibilities of contemporary history was stirred in 1805 by the Battle of Trafalgar, and he even went to Sheerness to visit the 'Victory' when she arrived home on 23 December 1805. With the sketches he made on board (cat.nos.39, 41 and 48) Turner started his large painting 'The Battle of Trafalgar, as seen from the Mizen Starboard Shrouds of the Victory' (Reserve Gallery 1), which was a public tribute both to a great victory, and more poignantly, to Nelson.

In a more contemplative vein Turner was, during this decade, producing intimate watercolour studies of the English landscape, notably the Thames studies of *c.*1805–6, subtly evoking the countryside that he loved; but as may be seen in the *Hesperides I* sketchbook, also exhibited (cat.no.50), this same scenery could itself be adapted to a number of meditations on classical themes directly inspired by Claude.

Turner's eclectic approach to his art, and the breadth of his achievement even at this early stage of his career, reached synthesis in his elaborate project the 'Liber Studiorum', a series of mezzotints for which Turner made drawings in six categories of subjects: Pastoral, Epic (or Elevated) Pastoral, Architectural, Marine, Historical and Mountainous. The first prints were issued on 11 June 1807, subsequent batches being published over a number of years, Turner himself sometimes etching the plate. By the close of the decade Turner had firmly established himself as an artist of immense ability and diversity.

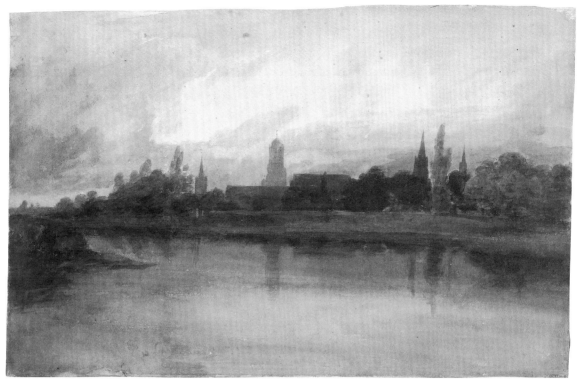

1 **Christ Church College, Oxford,**
from the River *c.*1800

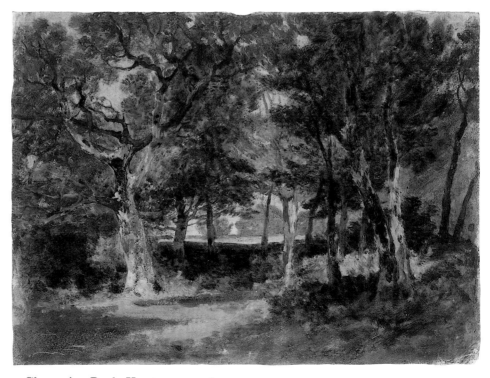

3 **Chevening Park, Kent** *c.*1799–1800

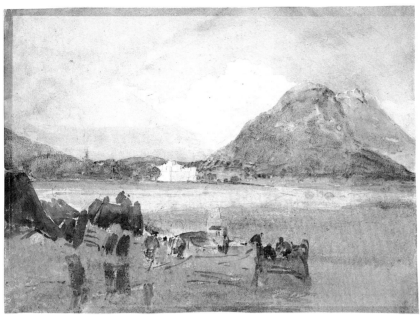

4 **Inverary Castle and Duniquoich Hill from
across Loch Shira, Scotland** *c.*1801

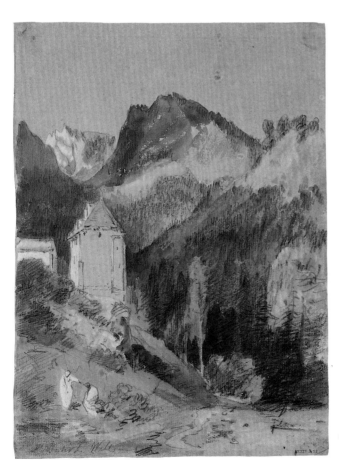

7 **The Little Church of St. Humber,
Grand Chartreuse** 1802

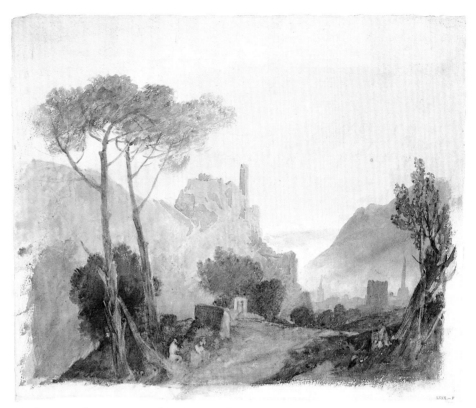

14 **Ruined Castle on a Hill overlooking a Town** *c*.1802–3

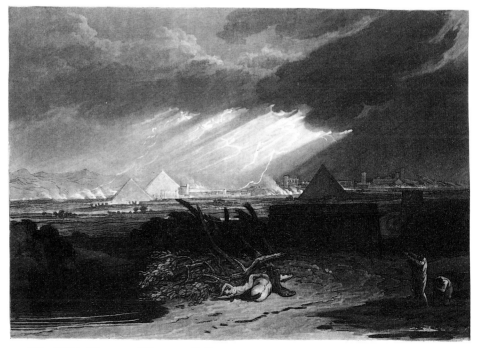

19 **The Fifth Plague of Egypt** 1808

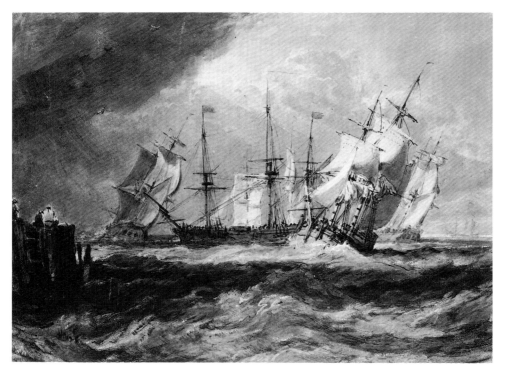

22 **The Egremont Sea Piece** *c.*1806–7

25 **River Scene with Eel Traps** *c.*1806

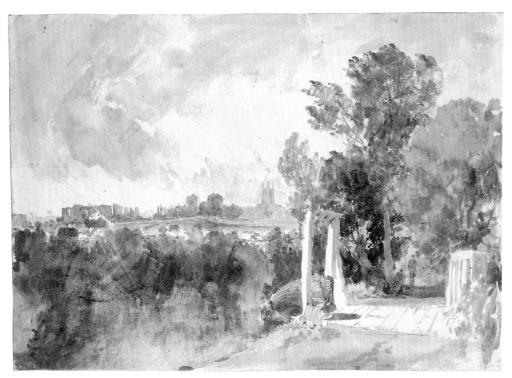

29 **Benson (or Bensington) near Wallingford**
 *c.*1805–6

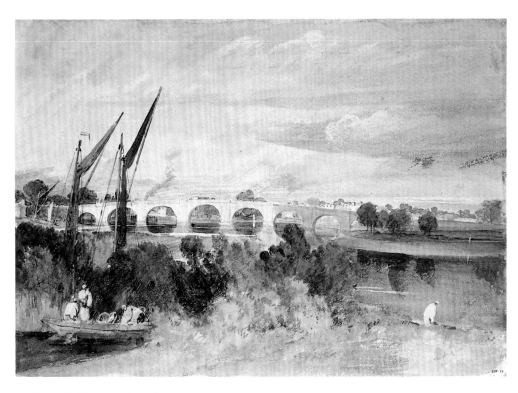

30 **Kew Bridge** *c.*1805–6

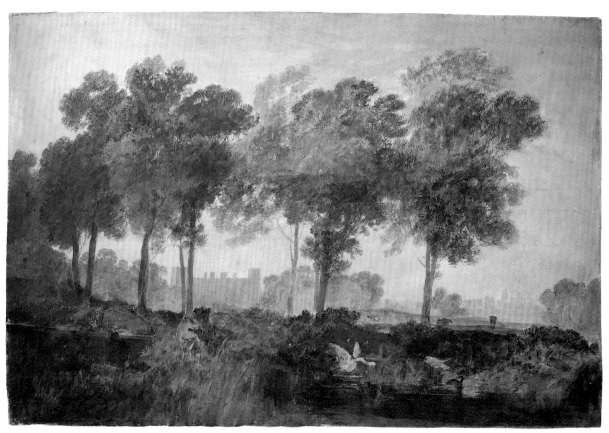

31 **The Swan's Nest: Syon House beyond**
 *c.*1805–6

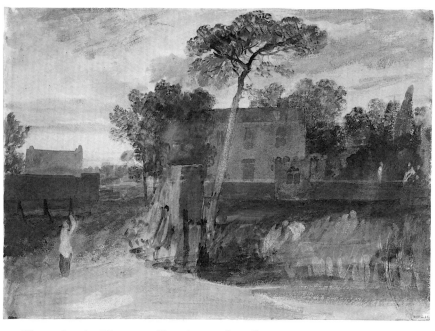

33 **House by the Thames: Evening** *c.*1805–6

36 **Brook and Trees** *c.*1806–7

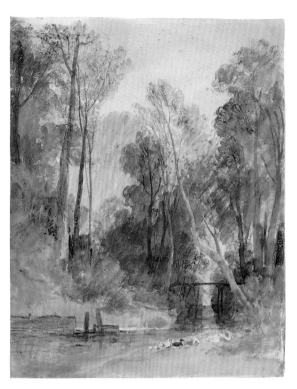

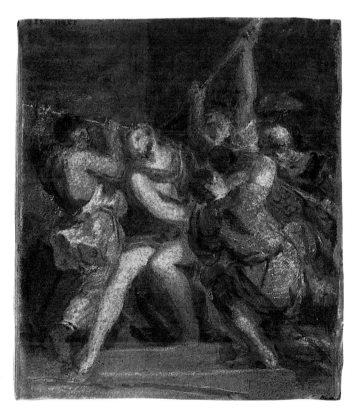

46 **'Studies in the Louvre'
sketchbook** 1802

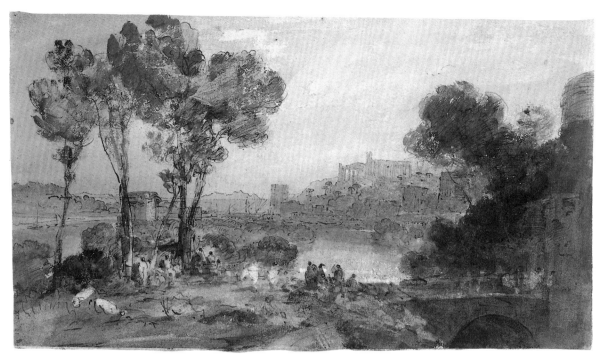

49 **'Studies for Pictures; Isleworth'**
sketchbook *c*.1804–5

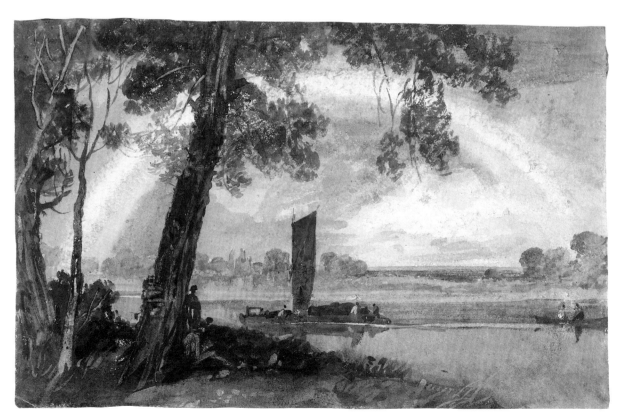

50 **'Hesperides I' sketchbook** *c*.1805–7

Catalogue

Catalogue

Measurements are given in millimetres followed
by inches in brackets; height precedes width.
Works illustrated in colour are marked *

1 **Christ Church College, Oxford, from the
River*** *c*.1800
Pencil and watercolour
264 × 416 (10⅜ × 18⅜)
Turner Bequest; CXXI G
D08262

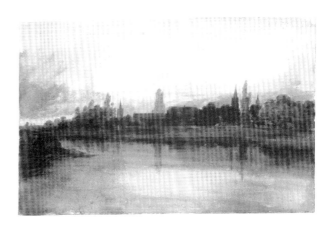

To be compared with Turner's finished watercolours for
the 'Oxford Almanack' this drawing depicts Oxford at
dusk from the meadows, with Tom Tower and Christ
Church Cathedral standing at the centre of the horizon.
Whilst the view is topographically descriptive it is also
more intensely personal and atmospheric than Turner's
commissioned and finished works from this period.
Turner has drawn freely with the brush only over the
slightest pencil indications.

2 **Stormy Landscape with Figures** *c*.1799–1800
Oil and watercolour or ink on sized paper
261 × 388 (10¼ × 15 5/16)
Turner Bequest; XCV(a) G
D05960

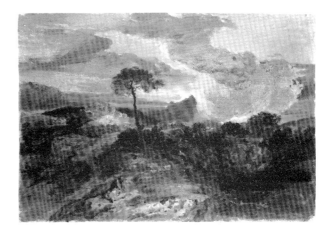

Although the use of oil on paper is found in Turner's
landscapes and interiors painted at Knockholt, Kent,
this sketch exemplifies the wilder and more Romantic
approach to nature associated with the current taste for
the Sublime. It is probably an independent study
associated with some projected painting, representing no
particular place but suggesting a narrative subject such
as the parable of the Good Samaritan.

3 **Chevening Park, Kent*** *c*.1799–1800
Oil and watercolour or ink on sized paper
278 × 378 (10 15/16 × 14⅞)
Inscribed verso '102 Chevening Park Kent'
Turner Bequest; XCV(a) D
D05957

One of a group of oil sketches on paper associated with
Turner's visits to his friend William Frederick Wells
(1762–1836), a landscapist and drawing master, at
Knockholt, Kent, from *c*.1799–1800. Quite possibly
painted out of doors, this and other Knockholt studies of
pastoral landscape anticipate the naturalistic water-
colour sketches of the Thames of 1805–6.

4 **Inverary Castle and Duniquoich Hill from across Loch Shira, Scotland*** *c.*1801
Pencil and watercolour
211 × 295 (8 5/16 × 11 5/8)
Turner Bequest; LX A
D03632

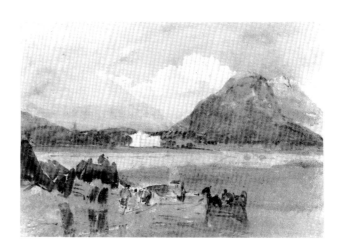

Turner toured Scotland for the first time throughout July and August 1801, leaving Edinburgh on 18 July and finishing up at Gretna Green on 5 August. He stayed longest at Inverary, judging from the number of studies of this area. Farington, who knew Scotland well, advised him on places to visit, although he encouraged him in June 1801 to postpone his trip, Turner having complained of 'being weak and languid' and even of 'imbecility'. Scotland seems to have inspired Turner towards a more developed and subtle treatment of the landscape. In this drawing his watercolour technique can be seen to have become extremely adept when freed from pencil outline. The artist much admired the Caledonian landscape, Farington recording that 'Turner thinks Scotland a more picturesque country to study in than Wales. the lines of the mountains are finer, and the rocks of larger masses'.

5 **Inverary from An Otir** 1801
Pencil and white bodycolour over paper prepared with a brown wash
342 × 491 (13 7/16 × 19 5/16)
Turner Bequest; LVIII 10
D03389

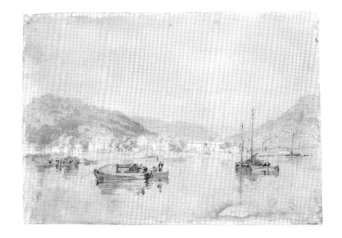

One of the 60 'Scottish Pencils', admired by John Ruskin, displaying a refined and subtly descriptive pencil style common only to this tour and that to the Continent in 1802. This drawing was the basis of a finished watercolour executed after Turner's return from Scotland (Manchester City Art Gallery). There is also a large colour study for this watercolour in the Turner Bequest (TB LX J). Farington comments on the 'Scottish Pencils' in his diary entry for 6 February 1802, reporting that Turner first washed the paper with a solution of '... India Ink and Tobacco water' and used a 'liquid white of his own preparing' for the highlights.

6 **'Edinburgh from Caulton-hill'** 1804
Pencil and watercolour
660 × 1000 (26 × 39⅜)
Turner Bequest; LX H
D03639

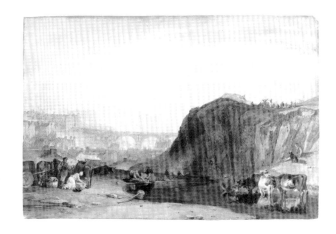

Based on a pencil drawing of 1801 from the *Smaller Fonthill* sketchbook, this large finished watercolour was exhibited at the Royal Academy in 1804. This is a topographical view, yet filled with narrative human incident, including milkmaids, washerwomen and a group of Scotsmen watching a dance. The activities of the figures are very similar to those recorded in the *Scotch Figures* sketchbook (cat.no.43) which Turner used on the tour of 1801.

7 **The Little Church of St. Humber, Grand Chartreuse*** 1802
Pencil, watercolour and bodycolour
284 × 212 (11 3/16 × 8 3/16)
Turner Bequest; LXXIV 32
D04525

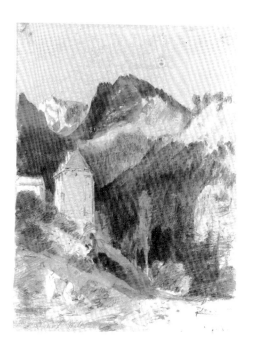

This drawing, made on Turner's first Continental Tour of 1802, is one of a large number described by Finberg as the contents of a *Grenoble* sketchbook but said by Ruskin to have been mounted in an album. It is in some respects similar in technique to the 'Scottish Pencils' Turner made the previous year, although here the artist has afterwards heightened the drawing with watercolour and white bodycolour.

8 **Roman Gate at Aosta** 1802
Pencil and bodycolour on brown paper
213 × 283 (8 3/16 × 11 5/32)
Turner Bequest; LXXIV 10
D04502

Another Continental study from the so-called *Grenoble* sketchbook which develops the style and technique of Turner's 'Scottish Pencils' executed the previous year: broad pencil work which has afterwards been touched with white bodycolour. Turner depicts the ancient Roman Gate, the Porta Praetoria, the Honorary Arch of Augustus which is situated on the road running East out of Aosta, now the Rue Humbert-Premier. Turner has carefully opposed the Classical symmetry of the arch to the rugged, soaring Alps and wild sky in the background. Ruskin commented about this drawing that 'Turner has been rather puzzled by the Swiss cottages, which were not reconcilable with academical laws of architecture. He sits down to his triumphal arch with great zeal, and a satisfied conscience.'

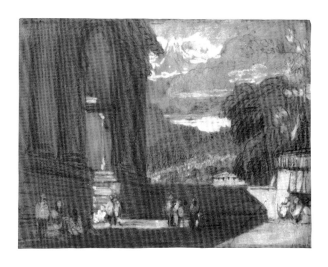

9 **Lyon** 1802
Pencil on grey paper
661 × 454 ($26\frac{1}{32}$ × $17\frac{7}{8}$)
Turner Bequest; LXXIX P
D04890

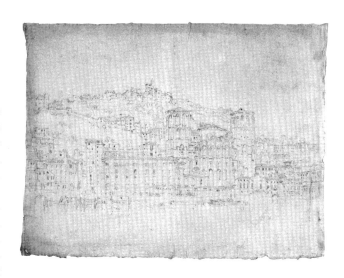

Turner spent three days in Lyon in late July. This detailed topographical sketch is the largest and most elaborate of the French drawings of 1802, and shows the heart of Lyon. The centre of the composition is occupied by the Cathedral of St Jean, built in the twelfth century, although damaged in the 1790s by the Revolutionaries. Abutting the Cathedral to the left is the Manécanterie, a choir school founded at the beginning of the fifteenth century. Rising behind the Cathedral is Fourvière hill, the site of the original Roman town. Turner has drawn this view from the eastern bank of the Saône, looking across the river, and was standing on what is now the Quai des Celestins. Turner told Farington that 'The buildings of Lyons are better than those of Edinburgh, but there is nothing so good as Edinburgh Castle.' However, he also complained of being charged 8 livres for a bed for the night, which he considered 'very dear', and was apparently unable to do much work there because 'place not settled enough'. Turner may have preferred to draw this urban landscape because, as he commented to Farington, 'The country to Lyons very bad'. The verso of this sheet bears a slight pencil study of the Cathedral of St Jean.

10 **Mont Blanc from Chamonix** 1802
Pencil, watercolour, pen and ink, and bodycolour on paper prepared with a grey wash
318 × 472 ($12\frac{1}{2}$ × $18\frac{19}{32}$)
Turner Bequest; LXXV 18
D04610

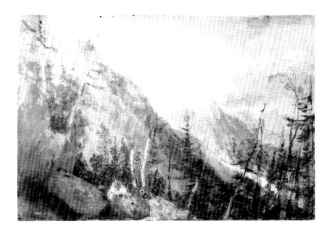

A sheet from the *St. Gothard and Mont Blanc* sketchbook, whose large leaves were prepared with a grey wash prior to drawing, this worked-up but unfinished watercolour would have begun as a sketch done on the spot, and further colour being added later. It is a work charged with the atmosphere of the Alps, and conveys the sombre coldness and barren quality of the region. Turner uses the pine trees in the foreground to good effect, although he apparently complained to Farington that 'The trees in Switzerland are bad for a painter'. This drawing is similar in treatment to the finished watercolours Turner did for Walter Fawkes and indeed, this sketch is the basis of the finished watercolour of 1809 commissioned by Fawkes 'The Valley of the Chamouni' (Whitworth Art Gallery, Manchester). The colours of this version are, however, less sombre than the Bequest drawing. The view of both is from the Montanvert.

11 **Bonneville** 1802
Pencil, watercolour and bodycolour on paper
prepared with a grey wash
314 × 472 ($12\frac{3}{8}$ × $18\frac{19}{32}$)
Turner Bequest; LXXV 7
D04599

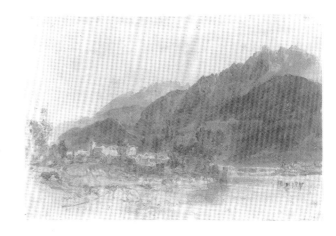

A page from the *St. Gothard and Mont Blanc* sketchbook,
this drawing would have been executed on the spot and
coloured at a later date. The sketch served as the basis for
the painting 'Bonneville, Savoy, with Mont Blanc'
exhibited by Turner in 1803 at the first Royal Academy
exhibition after his return from the Continent. In this
drawing, in contrast to many of Turner's views of the
Alps, the relatively calm and pastoral subject of the Arve
Valley is constructed on orderly classical lines.

12 **A Road among Mountains** 1802
Pencil, watercolour, and scraping out on paper
prepared with a grey wash
462 × 620 ($18\frac{3}{16}$ × $24\frac{13}{32}$)
Turner Bequest; LXXIX H
D04882

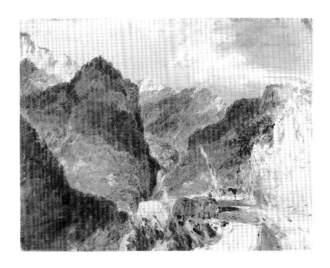

One of a group of larger studies of Swiss scenery made on
separate sheets, this is one of only two in the group to have
been worked up in colour. Such an elaborate exercise in
the texture and atmosphere of Alpine scenery cannot
have been achieved on the spot and the drawing was
possibly based on a sketch made in the *Lake Thun*
sketchbook. It is thought to show Dazio Grande on the
southern side of the St Gothard Pass with Piz Sole
beyond.

13 **Castle of Aosta** ?*c.*1802
Pencil and watercolour
200 × 273 ($7\frac{7}{8}$ × $10\frac{3}{4}$)
Turner Bequest; LXXX B
D04895

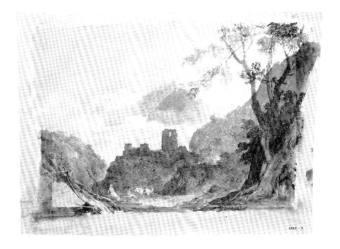

This crisp, bright watercolour study displays a lighter and
less sombre approach to the Alpine landscape by Turner.
He had, after all, told Farington that 'The weather was
very fine'. There is a study for this watercolour in the
'Grenoble' series, indicating that this drawing was
executed after Turner's return from the Continent.

14 Ruined Castle on a Hill overlooking a Town* *c.*1802–3
Pencil and watercolour
275 × 333 ($10\frac{13}{16}$ × 13)
Turner Bequest; LXXX F
D04899

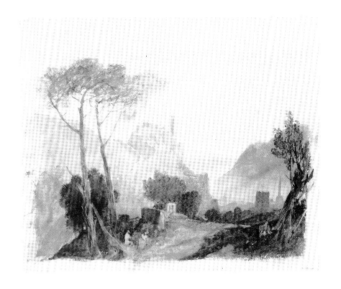

Although similar in treatment to the colour study of the Castle of Aosta (cat.no.13), this is quite possibly an imaginary scene.

15 Schaffhausen from below the Falls 1802
Pencil and bodycolour
555 × 724 ($21\frac{5}{8}$ × $28\frac{1}{2}$)
Turner Bequest; LXXIX D
D04878

The Falls of the Rhine at Schaffhausen, drawn here on a large independent sheet, was to be a favourite subject of Turner's. A nearer view of the Falls formed the subject of his painting exhibited at the Royal Academy in 1806 (Museum of Fine Arts, Boston), another was planned, but not executed, for the 'Liber Studiorum', and he made a number of watercolours of the falls on his Swiss visits in the 1840s. He may well have recalled P.J. de Loutherbourg's large painting of a rather similar view, exhibited in 1788 (Victoria and Albert Museum).

16 Fight of Centaurs and Lapithae *c.*1804
Pen and ink, pencil and chalk
464 × 624 ($18\frac{9}{32}$ × $24\frac{9}{16}$)
Turner Bequest; CXX W
D08237

This is a composition study, perhaps for a painting of a classical subject that was never executed. It appears to depict an incident related both by Homer in the *Iliad* and the *Odyssey*, and by Ovid in his *Metamorphoses*. The King of the Lapiths, Perithous, invited the Centaurs to his marriage. The Centaurs, half man, half horse, and symbolising to the Greeks lust and animal desire, tried to rape the bride and a battle ensued, in which the Centaurs were routed. This incident is depicted both on the pediment of the Temple of Zeus at Olympia and in the Elgin Marbles of the Parthenon at Athens, which arrived in England shortly after Turner's drawing was executed.

17 **Two Studies for Classical Subjects** *c.*1806
 Pencil
 240 × 379 ($9\frac{7}{16} \times 14\frac{15}{16}$)
 Turner Bequest; CXV 5
 D08088

A page from the *Studies for Liber* sketchbook, this would appear to bear two sketches for the 'Liber Studiorum', other subjects for which are exhibited. It is very close to other classical compositions for the 'Liber' but does not exactly correspond to any single plate. Turner seems to be playing with classical motifs – bridges, Claudean trees, picturesque ruins – moving them around to provide new, yet stereotypical compositions. These could, if appropriate, provide a background for a subject picture or a classical theme.

18 **Classical Composition** *c.*1805
 Pen and ink, with watercolour
 328 × 479 ($12\frac{7}{8} \times 18\frac{7}{8}$)
 Turner Bequest; CXX z verso
 D4000

Turner has inscribed this classical sketch with two possible titles: 'Homer Reciting to the Greeks his Hymn to Apollo' and 'Atalus declaring the Greek State to be Free'. No finished painting of either subject is known to have been executed by him. This summary study reveals how Turner first went about planning the composition of his work.

19 **The Fifth Plague of Egypt*** 1808
 Mezzotint
 204 × 285 ($8\frac{1}{32} \times 11\frac{7}{32}$)
 A00942

This print from the 'Liber Studiorum', in which Turner himself has etched the plate, is a version of the painting of the 'Fifth Plague' that Turner exhibited at the Royal Academy in 1800, now in the Indianapolis Museum of Art, Indiana. However, the painting was accompanied in the catalogue by a quote from Exodus, Chapter 9, verse 23, which suggests that the scene actually depicted is the Seventh Plague: 'And Moses stretched forth his hands towards Heaven, and the Lord sent thunder and hail, and the fire ran along the ground.' It has since been an area of critical debate whether Turner made this mistake out of ignorance, or whether some form of obscure irony was intended. 'The Fifth Plague of Egypt' was an exercise in History painting, much influenced by Poussin. Moses raises his hands, whilst the crouching figure behind him would appear to be Aaron, gathering the soot which Moses will throw in the air to initiate the Sixth Plague, that of boils; this is of course anachronistic in a rendering of the Seventh Plague.

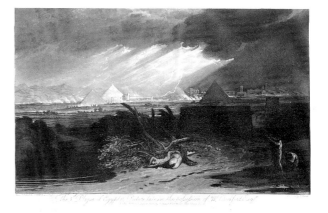

20 The Bridge in the Middle-Distance *c.*1807
 Watercolour, with pen and ink
 183 × 257 ($7\frac{3}{16}$ × $10\frac{1}{8}$)
 Turner Bequest; CXVI P
 D08117

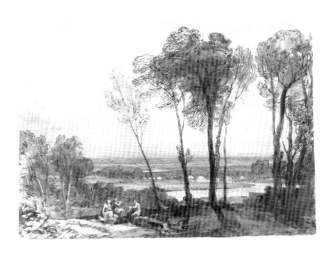

This drawing was engraved in mezzotint as Plate 13 of the 'Liber Studiorum', and was categorised in the Epic (or Elevated) Pastoral section of the series. Turner has 'borrowed' Walton Bridge from the Thames and placed it in a classical landscape.

21 Study for 'The Deluge' *c.*1804
 Pen and ink, pencil, and watercolour
 416 × 587 ($16\frac{1}{4}$ × $23\frac{1}{8}$)
 Turner Bequest; CXXX
 D08238

Turner much admired Poussin's 'Deluge' when he visited the Louvre in 1802, and this is a study for his painting of the subject (Gallery 107) probably exhibited in his own Harley Street gallery in 1805, and at the Royal Academy in 1813. The verso of this sheet bears a similar study for the painting.

22 The Egremont Sea Piece* *c.*1806–7
 Pencil and watercolour, with pen and ink
 180 × 259 ($7\frac{3}{32}$ × $10\frac{3}{16}$)
 Turner Bequest; CXVI M
 D08114

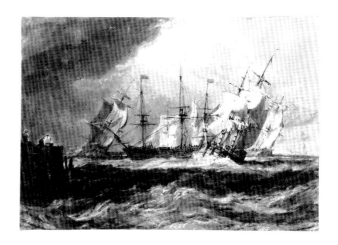

This is a watercolour version of the painting Turner exhibited at the Royal Academy in 1802, 'Ships bearing up for Anchorage', which was bought by the Earl of Egremont. This version is the drawing for Plate 10 of the 'Liber Studiorum', entitled 'Ships in a Breeze' and published in 1808 in the Marine section of the series. There are a number of sketches for this composition in the *Calais Pier* sketchbook, although these were undoubtedly for the painting rather than this drawing. A.G.H. Bachrach has noted the similarity between the ship occupying the centre of the composition and one of the model ships in Turner's possession (on display in Gallery 103).

23 **Bridge and Cows** *c.*1806–7
Pencil and watercolour
182×256 ($7\frac{5}{32} \times 10\frac{1}{16}$)
Turner Bequest; CXVI A
D08102

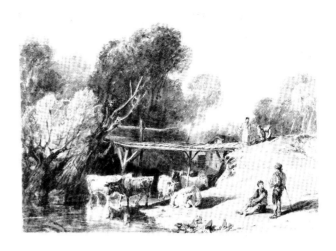

This drawing, epitomising the English pastoral, was engraved as the first plate of Turner's 'Liber Studiorum', and issued as a print on 11 June 1807. It was classified by Turner under the Pastoral category of the 'Liber'.

24 **Study for 'Harvest Home'** *c.*1809
Pencil, pen and ink and wash
188×229 ($7\frac{3}{8} \times 9\frac{1}{32}$)
Turner Bequest; CXX C
D08216

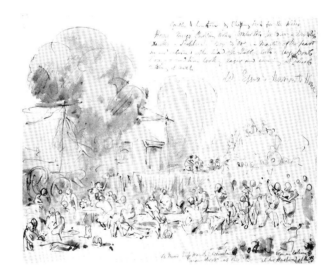

Turner's essays in rustic narrative had originally been inspired by the success of the young Scots painter David Wilkie with pictures like 'The Blind Fiddler' (Tate Gallery, Gallery 14), and there had subsequently been some competition between the two painters. This drawing is a study for Turner's unfinished genre painting 'Harvest Home' (Gallery 108), and details the scene of rustic revelry glimpsed through the barn doors in the painting. The artist has inscribed it '. . . Master of the feast demanding silence at the head of the table with a large bowl. Those around him looking eager and cunning at the hope of taking it next. –Four men half drunk wanting more beer at the barrel.' There are a number of related studies for 'Harvest Home' in the *Harvest Home* sketchbook (TB LXXXVI).

25 **River Scene with Eel Traps*** *c.*1806
Pencil and watercolour
230×375 ($9\frac{1}{16} \times 14\frac{3}{4}$)
Turner Bequest; CXV 3
D08086

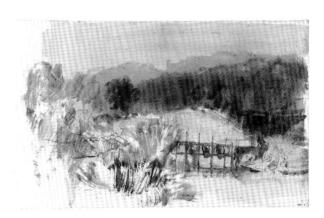

Although this drawing comes from the *Studies for Liber* sketchbook, Turner never developed it into a 'Liber Studiorum' subject. Two figures on the right of the composition appear to be removing eels they have caught.

26 Study for 'The Garreteer's Petition' *c*.1809
Watercolour and pen and ink
184 × 301 (7¼ × 11 13⁄16)
Inscribed 'ALMANACK / of Fasts and Moveable /
Feasts' and 'Translations Vida Art of Poetry Hints
for an Epic Poem Reviews torn upon Floor and /
Paraphrase of Job Coll. of Odds and Ends'
Turner Bequest; CXXI A
D08256

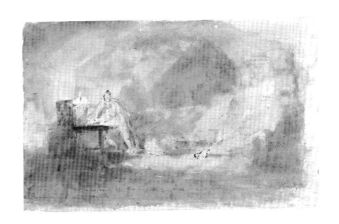

This study for the exhibited painting 'The Garreteer's
Petition' (Reserve Gallery 1), depicting a poet struggling
for inspiration, is another of Turner's forays into hu-
morous genre, a medium in which he was not wholly
successful. This, and also Turner's own efforts at poetry,
make the verses with which he exhibited the oil painting
in 1809 particularly ironic: 'Aid me ye Powers! O bid my
thoughts to roll / in quick succession, animate my soul /
Descend my Muse, and every thought refine / And finish
well my long, my long-sought line.' A companion
subject, studied in another contemporary drawing in the
Turner Bequest, depicts an amateur artist borrowing
inspiration from the old masters.

27 Pembury Mill, Kent *c*.1806–7
Pencil, watercolour, and pen and ink
181 × 252 (7⅛ × 9 29⁄32)
Turner Bequest; CXVI O
D08116

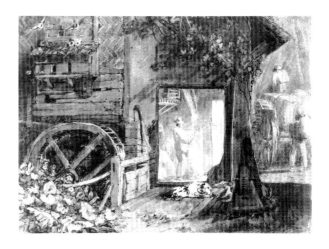

Pembury is situated three miles north east of Tunbridge
Wells, Kent, and it seems quite likely that Turner
became familiar with the mill there during his visits to his
friend W.F. Wells at Knockholt, some miles away. This
drawing, issued as Plate 12 of the 'Liber Studiorum' on
10 June 1808 in the Pastoral category, shows a scene of
picturesque rural industry, but also of commercial
exchange, as the miller is despatching his goods to
market. This is balanced on the left of the composition by
symbols of nature, as opposed to the commercial: wild
flowers and undergrowth, doves and a waterwheel, a
source of natural power.

28 A Group of Horses in Windsor Park *c*.1805–7
Pencil, watercolour and scratching out, with gum
arabic
577 × 771 (22 23⁄32 × 30 11⁄32)
Turner Bequest; LXX G
D04158

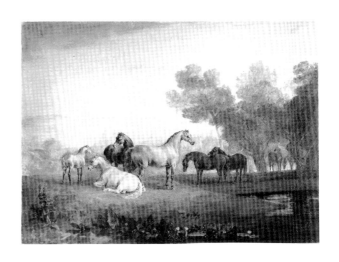

This finished watercolour, almost certainly that which
was exhibited at the Royal Academy in 1811, is a
collaboration between Turner, who painted the back-
ground, and his fellow Academician the sporting artist

Sawrey Gilpin (1753–1807), who painted the horses. Such collaborations were not unusual for Gilpin who worked with numerous artists during his career, including George Barret, Johan Zoffany and Philip Reinagle. Another of his contributions may be seen in the watercolour 'Donkeys by a Mine Shaft', also exhibited (cat.no.35).

29 Benson (or Bensington) near Wallingford*

c.1805–6
Pencil and watercolour
259 × 371 ($10\frac{3}{16}$ × $14\frac{19}{32}$)
Turner Bequest; xcv 13
D05917

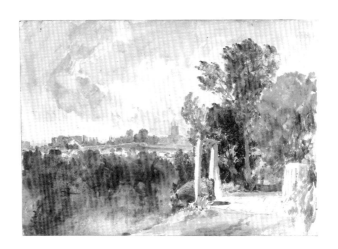

Started 'en plein-air', this is a sheet from the *Thames from Reading to Walton* sketchbook. Turner has skilfully employed bright colours, freely applied with a minimum of pencil underdrawing, and has left exposed areas of white paper to suggest the bright, flickering light of a blustery English summer's day. This drawing is another exercise in pastoral beauty, and shows figures in the foreground standing in the shade of some trees, with a footbridge and small eel trap nearby. In the distance Wallingford Church rises against the skyline, and to the left of this is a looming, massive structure which may be Wallingford Castle, although either it must have been in better repair in the early nineteenth century than today, or else Turner has exaggerated its proportions.

30 Kew Bridge* *c*.1805–6

Pencil and watercolour
256 × 364 ($9\frac{7}{8}$ × $14\frac{9}{32}$)
Turner Bequest; xcv 42
D05946

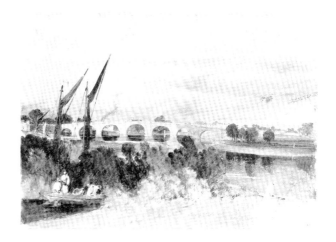

This page from the *Thames from Reading to Walton* sketchbook depicts Kew Bridge, which figures in many of Turner's paintings and drawings from the first decade of the nineteenth century, probably because it was near his home, Sion Ferry House, where he was living about 1805. This bright, freely painted watercolour, in common with most of the drawings in this sketchbook would seem to have been begun out of doors, like Turner's oil sketches of the Thames (Gallery 103) from the same period; it shows him at his most intimate, in harmony with the landscape he loved. The composition views Kew Bridge from Brentford Eyot, with Strand on the Green visible in the distance through the arches of the bridge.

31 **The Swan's Nest: Syon House beyond***
 *c.*1805–6
 Watercolour
 684 × 1013 (26⅞ × 39⅞)
 Turner Bequest; LXX L
 D04163

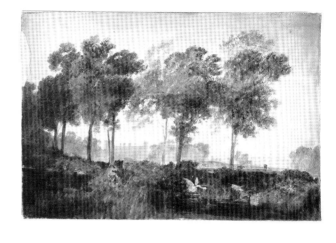

This large watercolour, which stands somewhere be-
tween the spontaneity of the smaller Thames water-
colours and the completeness of an exhibition subject, is
another exercise in the English pastoral ideal. It acknow-
ledges artistic conventions in its composition, based on
horizontal planes. The trees in the middle-distance are
presented 'contre-jour' whilst a golden glow suffuses
Syon House in the background. In its mellow lighting
and strong horizontal planes this drawing owes as much
to the Dutch seventeenth-century painter Aelbert Cuyp
(1620–91) as to the classical traditions of Claude. In
these respects it might well be compared with Turner's
oil painting exhibited in 1810, 'Dorchester Mead,
Oxfordshire' (Gallery 108).

32 **Thames River Scene** *c.*1805–6
 Pencil and watercolour
 260 × 365 (10$\frac{7}{32}$ × 14$\frac{3}{16}$)
 Turner Bequest; XCV 47
 D05951

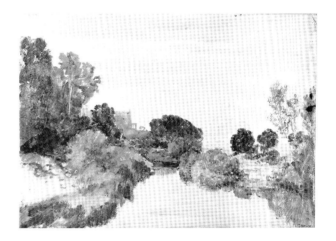

A page from the *Thames from Reading to Walton* sketch-
book, this watercolour has suffered badly from over-
exposure to light in the nineteenth century and from a
number of stains. The precise location depicted is
uncertain, although in common with other Thames
studies from this period it would seem likely to have been
started out of doors, perhaps from the boat that the son of
Turner's friend Henry Trimmer recorded that the artist
kept at Richmond.

33 House by the Thames: Evening* *c.*1805–6
 Pencil and watercolour
 260 × 369 ($10\frac{7}{32}$ × $14\frac{17}{32}$)
 Turner Bequest; XCV 48
 D05952

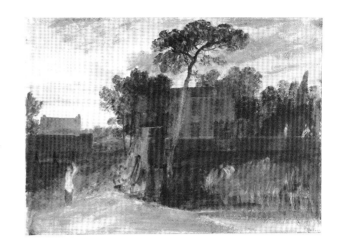

Another sheet from the *Thames from Reading to Walton* sketchbook. It has been suggested that this richly coloured drawing may depict a house on the Thames that was near to Turner's own residence during this period, Sion Ferry House. In this watercolour Turner beautifully evokes an English summer sunset, but the spontaneity of the execution is combined with a more formally structured composition, whose dual perspective is parted by a noble tree almost reminiscent of the heroic landscapes of Poussin. In the foreground a figure appears to wave to two others on the right, who seem to be cutting reeds from a boat.

34 The Ford *c.*1806
 Pencil, watercolour and bodycolour
 545 × 759 ($21\frac{7}{16}$ × $29\frac{7}{8}$)
 Turner Bequest; LXX K
 D04162

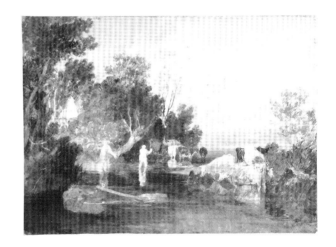

This large, unfinished watercolour in which Turner has used a warm and glowing palette, depicts a simple pastoral scene, in which echoes of Cuyp predominate. In common with other similar subjects Turner is presenting us with pastoral symbols – trees, water, cows, rustic figures – which he arranges into a variety of compositions in his works of this type, but which carry the same messages, the beauty of the English countryside and picturesque quality of rural life.

35 Donkeys beside a Mine Shaft *c.*1805–7
 Pencil, watercolour and bodycolour
 577 × 780 ($22\frac{11}{16}$ × $30\frac{11}{16}$)
 Turner Bequest; LXX I
 D04160

This drawing is another collaboration between Turner and Sawrey Gilpin RA (see cat.no.28) who had painted the donkeys, and the difference in approach to the handling of watercolour between the two artists can clearly be seen. In the background, highlighted against a bright sky, is a donkey gin: a donkey-powered winching system common in the early nineteenth century, which in this case is being used to bring material from the work face to the surface. The donkeys are resting after being released from the machinery.

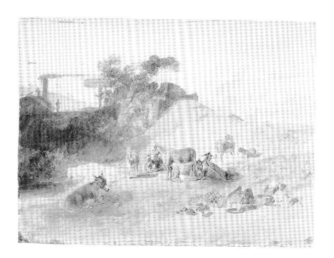

36 **Brook and Trees*** c.1806–7
Pencil and watercolour
289 × 228 ($11\frac{3}{8} × 8\frac{31}{32}$)
Turner Bequest; CXXI L
D08268

A scene of picturesque simplicity, this watercolour sketch bears some resemblance to part of the 'Liber Studiorum' subject 'Berry Pomeroy Castle', the footbridge in both being very similar.

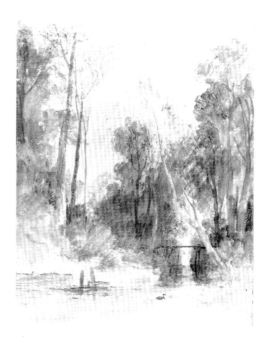

37 **Scarborough** c.1809
Watercolour
676 × 1010 ($26\frac{19}{32} × 39\frac{3}{4}$)
Turner Bequest; CXCVI C
D17167

This large sketch, with colour freely applied, is a study for the finished watercolour 'Scarborough' (Private Collection) exhibited at the Royal Academy in 1811. It is one of a large number of such 'colour beginnings' in the Turner Bequest. These are essentially studies in tonal relationships in which only the most important compositional masses were blocked in; these seem sometimes to have been independent experiments in pictorial construction, but others like this served as the basis for more finished watercolours painted separately. In the finished 'Scarborough' Turner put in anecdotal details of children playing on the beach and women hanging out clothes to dry on the rocks that are to the left of the composition; he follows the tonal patterns and lighting of this study quite closely, save for some deepening of the shadows in the left foreground.

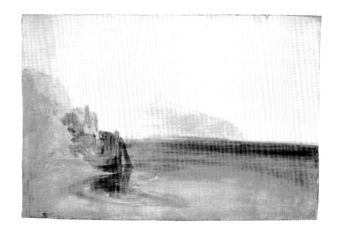

38 **The 'Victory' coming up the Channel with the Body of Nelson** *c.*1806–8
Watercolour and pen and ink
200×285 $(7\frac{7}{8} \times 11\frac{7}{32})$
Turner Bequest; CXVIII c
D08183

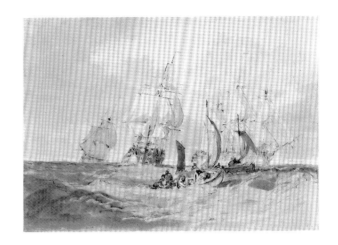

This drawing appears to be an unpublished 'Liber Studiorum' subject, and is a version of the oil painting of 1806 'The 'Victory' returning from Trafalgar' (Yale Centre for British Art, New Haven) that Turner sold to Walter Fawkes, his friend and patron. Both this drawing and the oil painting fit into the category of ship portraiture, in which it was common, as here, to show three views of the same ship: bow, port and starboard. The traditional title of the painting has however always been problematical as the ships portrayed there and in this drawing are not at all like the 'Victory'. As Turner knew, the ship was so badly damaged, having lost her mizzen mast and half her main mast, that she had to be towed from Trafalgar, and even after repairs at Spithead had only temporary jury masts unlike those depicted. Moreover, the 'Victory' did not sail past the Needles as Turner has shown her in the oil, and if Nelson's body were on board her flags would have flown at half mast.

39 **The Quarterdeck of the 'Victory'** 1805
Pencil, watercolour and pen and ink
424×565 $(16\frac{11}{16} \times 22\frac{1}{4})$
Turner Bequest; CXXI s
D08275

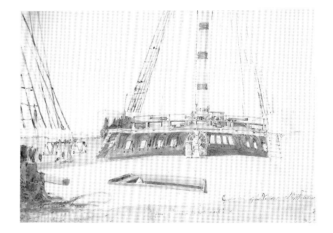

Inscribed in Turner's hand: 'Quarter Deck of the Victory JMW Turner', 'Guns 121lb. used in the Ports marked i.x', 'Splinter hitting marks in pencil/ 9 inches thick'; 'Rail shot away during the action'. Turner drew the outline of this detailed drawing on board the 'Victory', even noting the extent of damage in his inscriptions. He appears to have boarded the ship very soon after her arrival at Sheerness on 23 December 1805, for Nelson's body was still on board before it was removed on to the yacht 'Chatham' and taken up the Thames to Greenwich Royal Naval Hospital, where it arrived on 24 December. This drawing may well have been in the collections of both Dr Thomas Monro and Samuel Rogers if the additional inscriptions to that effect are accurate; its presence in the Bequest must make this unlikely.

40 Key to 'The Battle of Trafalgar' 1806
Watercolour and pen and ink
$186 \times 234 \left(7\frac{5}{16} \times 9\frac{7}{8}\right)$
Turner Bequest; CXXI K
D08266

This document is a key to the principal figures seen in Turner's large painting 'The Battle of Trafalgar' (Reserve Gallery 1), and beneath is a description by Turner of the precise action of the battle at the moment that Nelson was shot. The artist is reputed to have given this key to visitors to his gallery when the painting was exhibited there in 1806. It was badly damaged in the Thames flood of 1928 making much of the text illegible. A transcript is therefore exhibited alongside, although despite ultra-violet scanning several words are still unreadable.

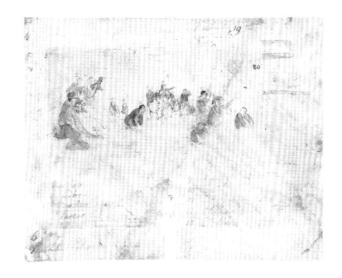

> The front of the picture is occupied by the Poop of the Victory defended by the Marines with the signal men and Midshipmen who took care of the signals after Lt Pascoe was wounded [in] the left and lower corner seamen endeavour to secure the mizzen mast which after the action fell overboard. In the centre is Lord Nelson with the officers and seamen that attended to him after he was wounded and carried off the Quarter deck. between the main and Foremast the decks are covered with seamen. the marines on the starboard side were commanded by Capt. Adair who was killed by the riflemen in the mizen top of the Rebuobtable entangled with the Victory's fore shrouds [.] her Captain is halling down his Colors and some of the crew [are] hailing for quater [.] over her shattered stern is The Temeraire 98 guns Adl Harvey. ingaged with the Fogieux and part of the french line. The Neptune Capt. Freemantle bearing up to engage the Beaucentaur Adl Villeneuve and St Trinadada (seen thro the smoke) bearing the Spanish Adm flag at the Main over the Bows of the Victory is the Le Intrepide, French 74. . . .

The names on the plan are as follows:

1 Marshall
2 Lt Peake RM
3 Marshall SignalsMan
4 Lt Pascoe RN wounded
5 Robinson Midshipman
6 illegible
7 Lancaster Midshipman
8 Rivers Midshipman
9 Master's Assistant
10 Capt Hardy
11 Lt Richy [Rothy ?] RM
12 Atkinson Master
13 Lt King
14 illegible
15 Lord Nelson
16 Lt Brown
17 Lt Williams
18 Lt Reeves R Marines
19 Viscount M[rest illegible]
20 Signal for close [of] Action

41 The 'Victory' 1805
Pencil
$471 \times 756 \left(18\frac{17}{32} \times 29\frac{23}{32}\right)$
Turner Bequest; CXX C
D08243

A large and detailed pencil study executed on board the 'Victory'; the broad pencil strokes in which the masts are drawn give a sense of the battered condition of the ship. This drawing is very much in the manner of the smaller sketches Turner made in his *Nelson* sketchbook (cat.no.48) which he had with him when he went to see the arrival of the 'Victory'.

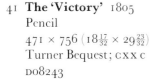

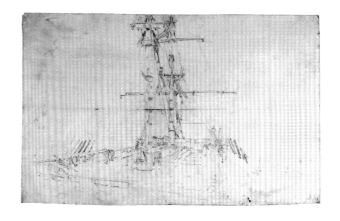

42 The Battle of Trafalgar, as seen from the Mizen Starboard Shrouds of the Victory
Photograph

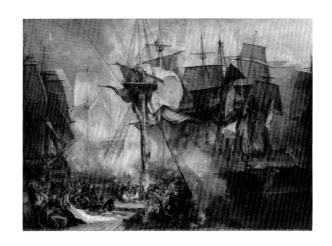

Turner's oil painting of 1806 (Turner Bequest; Reserve Gallery 1) is a carefully reconstructed depiction of the moment that Nelson fell, information probably being obtained in part from his interviews of the ship's crew when he met the 'Victory' on her return to England. Turner significantly places Nelson in a pose and in a compositional group of figures highly reminiscent of old master depictions of the removal of Christ from the cross. The painting shows the moment of victory as well as that of Nelson's fatal wounding, a sailor bringing forward a French flag. In the background, silhouetted, is a Royal Marine firing a musket, apparently shooting the sniper who had shot Nelson from the 'Redoubtable'. A critic for the 'Review of Publications of Art' for 1808 commented on this painting that 'Mr Turner has detailed the death of his hero, while he has suggested the whole of a great naval victory, which we believe has never before been successfully accomplished.'

43 *Scotch Figures* sketchbook 1801
Three Scotsmen in Tartan
Pencil and watercolour
154×91 $(6\frac{1}{32} \times 3\frac{9}{16})$
Turner Bequest; LIX 5, 6
D03446

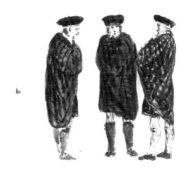

The *Scotch Figures* sketchbook, one of those Turner took with him on his Scottish tour of 1801, contains studies of Scots peasants often involved in rural labour. This study depicts three men at rest, in traditional dress.

44 *Edinburgh* sketchbook 1801
St. Giles' and Edinburgh Castle from the East; St. Anthony's Chapel in the Foreground
Pencil and watercolour
195×125 $(7\frac{5}{8} \times 4\frac{27}{32})$
Turner Bequest; LV 5 verso, 6
D02818, D02819

From another of the sketchbooks Turner took to Scotland in 1801, this slight but evocative watercolour sketch, in which the colour washes have been freely applied, is one of a series of such studies in the sketchbook that depict Edinburgh Castle.

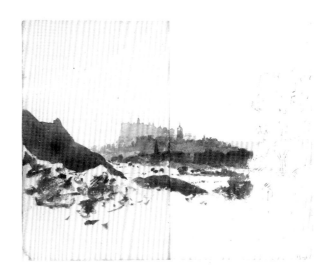

45 *Swiss Figures* sketchbook 1802
Nude Swiss Girl on Bed; a Companion beside her
Pencil and watercolour
161 × 195 ($6\frac{5}{16}$ × $7\frac{21}{32}$)
Turner Bequest; LXXVIII
D04798

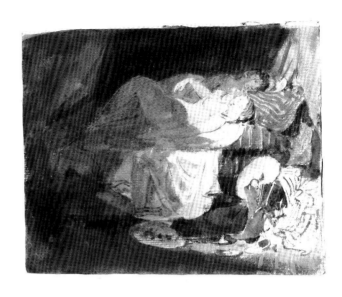

In a sketchbook that contains mainly studies of Swiss peasants this drawing stands out as an essay from the erotic side of Turner's psyche. Whether this is an imaginary scene is uncertain. The girl's companion would appear to be another woman, for there are two hats and sets of clothes abandoned on the floor.

46 *Studies in the Louvre* sketchbook 1802
Copy after Titian's 'Christ Crowned with Thorns'*
Pencil and watercolour
127 × 115 (5 × $4\frac{1}{2}$)
Turner Bequest; LXXII 51 verso, 52
D04339, D04340

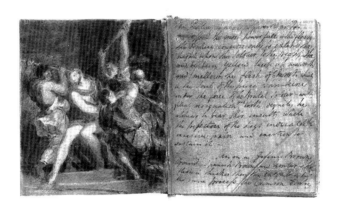

This sketchbook accompanied Turner on his visits to the Louvre in 1802, where he was so much impressed by the works of the old masters, making watercolour copies of them and writing his comments by the side. This copy of Titian's masterpiece (still in the Louvre) is accompanied on the opposite page by comments which include the following: 'The most powerful is the flesh, the drapery answers only to extend the light upon the soldier to the right, and by being yellow keep up warmth and mellow the flesh of Christ, which is the soul of the piece shrinking under the force of the Brutal . . .'.

47 *Shipwreck (No.1)* sketchbook
Study for 'The Shipwreck' *c.*1804
Pen and ink and watercolour
117 × 181 ($4\frac{19}{32}$ × $7\frac{1}{8}$)
Turner Bequest; LXXXVII 16, 17
D05391, D05392

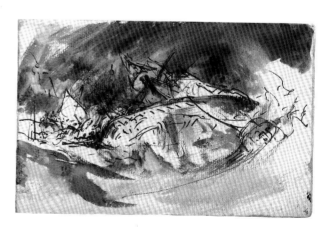

This sketchbook spread shows two studies for Turner's oil painting 'The Shipwreck' (Gallery 107) exhibited in 1805. Quite possibly these sketches, in common with others that appear in the sketchbook, may be of actual wrecks. 'The Shipwreck' was the first of Turner's paintings to be engraved, winning both commercial and critical success.

48 *Nelson* sketchbook 1805
Study of the 'Victory'
Pencil
115 × 180 ($4\frac{1}{2}$ × $7\frac{1}{16}$)
Turner Bequest; LXXXIX 28 verso, 29
D05486, D05487

Turner took this sketchbook with him on board the 'Victory' and made a series of sketches in it of the ship and her crew. This spread shows two views of the 'Victory', one close to (illustrated), the other from a distance.

49 *Studies for Pictures; Isleworth* sketchbook *c*.1804–5
Study for 'Dido and Aeneas'*
Watercolour and pen and ink, with some scratching out, on paper prepared with a grey wash
144 × 255 ($5\frac{5}{8}$ × $10\frac{1}{32}$)
Turner Bequest; XC 20 verso, 21
D05519, D05520

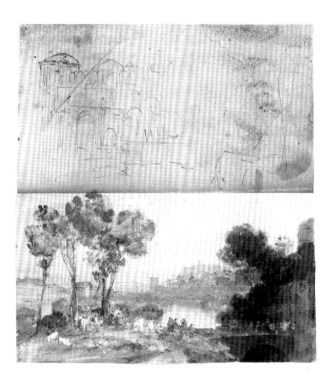

Turner's painting 'Dido and Aeneas' (Gallery 106) was exhibited at the Royal Academy in 1814, a critic writing in *The Champion* that, with some reservations, the painting was one 'of which our nation has reason to be proud'. This watercolour sketch is the first known study for the painting, and many other classical history subjects are contained in the sketchbook. However, it also contains a number of picturesque English studies, many apparently of scenes along the Thames, and they can be compared with Turner's watercolour studies in the *Thames from Reading to Walton* sketchbook (cat.nos.29, 30, 32, 33).

50 *Hesperides I* sketchbook *c*.1805–7
River Scene with Rainbow*
Watercolour
167 × 266 ($6\frac{9}{16}$ × $10\frac{7}{16}$)
Turner Bequest; XCIII 42 verso, 43
D05840, D05841

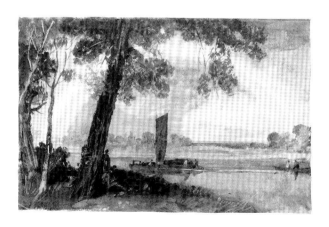

This beautiful watercolour study can be compared with Turner's Thames studies in the *Thames from Reading to Walton* sketchbook (cat.nos.29, 30, 32, 33), of roughly the same period. The view is also likely to be on the Thames.

51 *Calais Pier* sketchbook *c.*1802
Study for 'Ships Bearing up for Anchorage'
('The Egremont Sea Piece')
Pen and ink, wash, and black and white chalk on
blue paper
440 × 260 ($17\frac{5}{16}$ × $10\frac{7}{32}$)
Inscribed in Turner's hand 'Ld Egremont's Picture'
Turner Bequest; LXXXI 72, 73
D04974, D04975

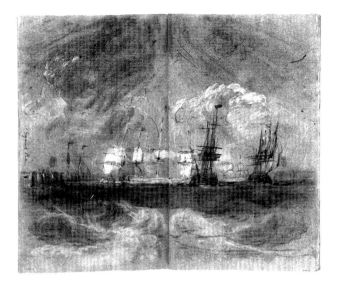

A study for the oil painting exhibited in 1802, another
version of which formed a subject for the 'Liber
Studiorum' (cat.no.22). The *Calais Pier* sketchbook is full
of studies in pen and ink or chalks for some of Turner's
most famous oil paintings of this period, although it also
has several sketches depicting his hazardous landing at
Calais on his first Continental tour. It is one of the largest
in the Turner Bequest.

Select Bibliography

Martin Butlin and Evelyn Joll, *The Paintings of J.M.W. Turner*, Yale, New Haven and London, 1984

Joseph Farington, *The Diary of Joseph Farington*, Edited by Kathryn Cave and Kenneth Garlick, Yale, New Haven and London, 1978–84

Alexander J. Finberg, *A Complete Inventory of the Drawings of the Turner Bequest*, National Gallery, London, 1909

Alexander J. Finberg, *The History of Turner's Liber Studiorum, with a new Catalogue Raisonné*, Ernest Benn, London, 1924

Alexander J. Finberg, *The Life of J.M.W. Turner RA*, Clarendon, Oxford, 1921

John Gage, *J.M.W. Turner : 'a wonderful range of mind'*, Yale, New Haven and London, 1987

Andrew Wilton, *The Life and Work of J.M.W. Turner*, Academy, London, 1979

Andrew Wilton, *Turner in his Time*, Thames and Hudson, London, 1987

Andrew Wilton and John Russell, *Turner in Switzerland*, De Clivo, Zurich, 1976